JEFF WALL

JEFF WALL

NORTH & WEST

THIS CATALOGUE WAS PREPARED FOR
THE AUDAIN ART MUSEUM EXHIBITION
JEFF WALL: NORTH & WEST

Figure.1
Vancouver / Berkeley

AUDAIN ART MUSEUM
Whistler BC Canada

Contents

SUZANNE E. GREENING
Executive Director, Audain Art Museum

Foreword

WHEN CONSIDERING WHAT the inaugural temporary exhibition would be at the Audain Art Museum when it opens in early 2016, Michael Audain asserted that it should be an artist from British Columbia in order to reflect the focus of the museum. Michael also believed that it would be an honour and appropriate if Vancouver artist Jeff Wall, who has exhibited his photographs internationally for thirty-five years and is considered to be one of the most prominent contemporary artists working today, could be featured in our first temporary exhibition. The only Canadian artist to date to be accorded a solo exhibition at New York's Museum of Modern Art, Jeff has played a key role in establishing photography as a contemporary art form. We are thrilled to present *Jeff Wall: North & West* at the Audain Art Museum.

Jeff Wall is known for his large-scale backlit photographs, his critical writing, and his teaching. He received an MA from the University of British Columbia (UBC) in 1970 and did postgraduate work at the Courtauld Institute in London, England. He served as an assistant professor at the Nova Scotia College of Art & Design (1974–75), an associate professor at Simon Fraser University (1976–87), and, until 1999, a professor at the University of British Columbia.

In the late 1970s, after a period of experimentation with conceptual art while a graduate student at UBC, Jeff produced his first backlit photographs. The lightbox became a platform for his figurative tableaux, street scenes and interiors, landscapes and cityscapes. He has explored themes such as the relationships between men and women, beauty and decay, and the boundary between metropolis and nature. Much of his work depicts intersections, suburbs, dead zones, social tension, and cities with changing demographics. In the mid-1990s he began producing black-and-white silver gelatin prints.

Jeff's works are not snapshots, but rather each is a constructed scene and requires the viewer to investigate, question, and interpret. Turmoil, ambiguity, and suspense can be found throughout.

Jeff Wall is the recipient of numerous honours: in 2002 he received the Hasselblad Award, in 2006 he was named a Fellow of the Royal Society of Canada, in 2007 he was appointed an Officer of the Order of Canada, and in 2008 he received the prestigious Audain Prize.

A great number of the works in this exhibition have been travelling in Europe since early 2014 in Jeff's solo exhibition, *Tableaux Pictures Photographs 1996–2013*, at the Stedelijk Museum Amsterdam, the Kunsthaus Bregenz, and the Louisiana Museum of Modern Art, Humlebæk. We could not have navigated the logistics of this exhibition without the assistance of Jeff's registrar, Kevin Doherty, who helped with information and bringing the pictures back to Canada, and technician Alex Clarke, who is responsible for the installation of Jeff's work. The finalizing of the catalogue would not have been possible without technical and administrative support from Chief Curator Darrin Martens and Barbara Binns, Michael Audain's executive assistant, working in conjunction with the professional team of editorial and design staff at Figure 1 Publishing Inc.

We thank as well Vancouver author Aaron Peck, who is also known for his art criticism and teaching, and who, through his essay, has paved the way to a better understanding of Jeff's inspiration and work.

Finally, we are eternally grateful to Jeff Wall for his friendship, graciousness, and willingness to assist in the creation of this exhibition and the launch of the Audain Art Museum.

MUSEUM BEGINNINGS

EARLY 2016 MARKS an occasion worth remembering in Whistler, British Columbia. Through the vision and generosity of Michael Audain, a fifth-generation British Columbian, and his wife, Yoshiko (Yoshi) Karasawa, an incredible legacy is being realized in the form of the Audain Art Museum.

Having been convinced by others that their extensive art collection should be viewed and appreciated by as many art lovers as possible, Michael and Yoshi began to consider the final resting place for their art. Among the highlights of this boutique collection are one of the world's most important representations of centuries-old Pacific Northwest Coast masks; over two dozen of the finest works by Emily Carr (lately acknowledged as one of history's most important female artists); the largest collection of British Columbia artist E.J. Hughes's paintings, donated on a long-term loan by Jacques Barbeau and his wife, Margaret Ann Owen; art by some of Canada's most significant postwar modernists, including Jack Shadbolt and Gordon Smith; plus works by internationally collected contemporary artists Jeff Wall, Rodney Graham, Stan Douglas, Geoffrey Farmer, Robert Davidson, and Brian Jungen.

In October 2012, Michael and Yoshi entered into an agreement with the Resort Municipality of Whistler to build a 2,300 square metre (25,000 square feet) museum—later increasing in size to 5,200 square metres (56,000 square feet)—to house the West Coast portion of their collection. And to ensure visitors would have something new to see on a regular basis, temporary galleries were designed that could host exhibitions of works by important artists from the rest of Canada and around the world.

A A R O N P E C K

Boy on a Bicycle

1 Baudelaire, Charles, "The Swan," *Charles Baudelaire's Fleurs du mal / Flowers of Evil*, www.fleursdumal. org/poem/220 (accessed February 12, 2015).

2 Wall, Jeff, "'Marks of Indifference': Aspects of Photography in, or as, Conceptual Art," *Jeff Wall: Selected Essays and Interviews* (New York: Museum of Modern Art, 2007), pp. 143–44.

JEFF WALL RECENTLY made a simple but revealing comment: that the artists of his generation are responding to the memory of a past Vancouver. He remarked that much of the downtown peninsula used to be parking lots, which he remembers from bicycling around the city as a young boy.

We learn how to look at the world from seeing the things around us. The kinds of buildings or spaces we expect to see, even the various ways our eyes glance, or scan a scene—all of these are the product of our visual environment. The city that taught Wall to see has changed. In 1861, Charles Baudelaire memorialized a similar circumstance in Paris: "The form of the city / changes more quickly, alas! than the human heart."[1] Baudelaire's lines may be a bit melancholy for Wall's aesthetic disposition, but they tell us something about how an individual relates to a place over time: places necessarily change, and yet their inhabitants remain. We outlive our cities in the same way we do parts of our family. What once was ours disappears, and its ways of seeing vanish with it. And yet its children, who have grown into adults, remain.

Born in 1946, Wall has lived his entire life in Vancouver, with the exception of three years in London and one in Halifax. His father was a doctor, and his mother stayed at home to raise the children. By the mid-1960s, Wall was a student at the University of British Columbia (UBC), which had a small coterie of architects, poets, critics, and artists who were engaged with contemporary art, giving a generation of young people the space to experiment and think. Before he began to make the large-scale photographic works for which he has become known, he was interested in conceptual art, a movement with which he soon parted ways and later critiqued.[2] At UBC, he studied primarily with

Ian Wallace—a peer only three years older, who had taken a teaching job at UBC after finishing his own master's degree—who, like Wall, was responding to emergent forms of the avant-garde originating out of New York, Los Angeles, Paris, and West Germany. Involved in the protest art of the 1960s, Wall completed his master's on the political implications of Berlin Dada, employing the ideas of Frankfurt School writers such as Herbert Marcuse and Max Horkheimer, all recently translated into English. At the same time, an early artwork of Wall's, *Landscape Manual* (1969)*—a kind of juvenilia that imitated André Breton's 1926 surrealist novel *Nadja*, which incorporated text, documentary photography, and drawing—was exhibited in *Information*, a major survey of conceptual art at the Museum of Modern Art in 1970.

Then Wall stopped exhibiting and made no new work for seven years. Still considering himself an artist, however, he took this "hiatus" to pursue research, calling it "an impersonation of a radical art historian."[3] When Wall was accepted to the Courtauld Institute of Art in 1970, he and his wife, Jeannette, moved to London, where he intended to complete a Ph.D. on the ready-mades of Marcel Duchamp.[4] He regularly viewed work in the Courtauld's collection, such as Édouard Manet's *A Bar at the Folies-Bergère* (1882),[5] while also attending screenings at the film clubs and cinematheques of London and Paris: Italian neo-realist films of the 1940s and 1950s, the French Nouvelle Vague of the 1960s, Structuralist films of the 1960s, and early examples of the New German Cinema of the 1970s. From London, he visited exhibitions of contemporary art across Europe, including Documenta 5 in 1972. During these London years, he also developed dialogues with a group of peers—artists, critics, filmmakers, curators, and art historians—who would become significant for him in the coming decades.

After returning to Vancouver in 1973, now with two sons, Wall accepted a job in the art history department at the Nova Scotia College of Art & Design and moved the family to Halifax, which at the time was a hub for conceptual art. They returned to Vancouver the following year, because the winter was too much, and Wall has lived in Vancouver ever since. Back on the West Coast, he taught part-time at Simon Fraser University (SFU), where, in 1976,

3 Wall, Jeff, unpublished notes given to the author, n.p.

4 By the mid-1970s, after he had seen the Duchamp exhibition at the Philadelphia Museum of Art in October 1973, *The Large Glass* (1915–23) and *Étant Donnés* (1946–66) would become even more significant for Wall, because he began to understand Duchamp's masterpieces as expansions of European art, not as critiques of it. See Wall, Jeff, *Marcel Duchamp: Étant Donnés* (Nürnberg: Verlag für moderne Kunst, 2013).

5 Campany, David, *Jeff Wall: Picture for Women* (London: Afterall, 2011), p. 5.

*not included in this catalogue

6 Wallace, Ian, "Some Correspondences in Retrospect," *Jeff Wall: Vancouver Art Gallery Collection* (Vancouver: Vancouver Art Gallery, 2008), p. 35.

7 Beck, Claudia and Gruft, Andrew, "A Journey of Imagination," *Real Pictures: Photographs From the Collection of Claudia Beck and Andrew Gruft* (Vancouver: Vancouver Art Gallery, 2005), pp. 7–8.

8 Wall, Jeff, *Jeff Wall: Catalogue Raisonné: 1978–2004*, ed. Theodora Vischer and Heidi Naef (Basel: Schaulager, 2005), p. 339.

9 His cinematographic works have thoroughly entered the popular imagination. Two of these pictures, in fact, *The Destroyed Room* and *After "Invisible Man,"* are so influential that they recently "inspired" the recording artist Sia to perform, without permission, on a set oddly resembling them during the 2015 Grammys. Furthermore, *The Destroyed Room* was also the borrowed title of a 2006 Sonic Youth album, which, with permission, featured Wall's picture as cover art. And while on the tangent of Wall's influence in pop music, Iggy Pop had Wall take his portrait for the cover of Pop's 1999 album *Avenue B*. Not to mention Wall's own participation in the short-lived Vancouver-based art-punk band UJ3RK5, also with Ian Wallace and Rodney Graham, which released one album in 1980 on Quintessence Records.

10 A word on his titles: I have always wondered why Wall capitalizes them so eccentrically. Starting in 2000, for most titles, he removed capitalization of all words except the first, as if his titles were grammatical sentences, or in *le style français*.

11 Wall, Jeff, *Jeff Wall: Catalogue Raisonné: 1978–2004*, ed. Theodora Vischer and Heidi Naef (Basel: Schaulager, 2005), p. 339.

*not included in this catalogue

he was offered a full-time position, in charge of developing a new studio arts program. As a teacher at SFU, and then later at UBC, Wall would go on to influence Vancouver-based artists for two decades, and then even longer, hiring young artists as studio assistants after he quit teaching.

In terms of Wall's own still-developing work in the 1970s, cinema would provide a significant production model for his photographic tableaux. He was active in the local film scene in Vancouver, programming movies at the Pacific Cinematheque in 1974 and 1975. There was even a never-completed narrative film, *Summer Script*, with Rodney Graham and Ian Wallace.[6]

In 1978, Wall first publicly exhibited his photographs as large-scale backlit transparencies, often called "lightboxes," at Nova Gallery, which was run by curator-critic Claudia Beck and local architect Andrew Gruft.[7] Since then, his work has continued to explore depiction within the context of contemporary art. His approach to photography provided an alternative to what is often called fine art photography, which displays photographic art in books or as mid-sized prints. Wall may not have been the first artist to use backlit transparencies in art, but he was the first to do so on a large scale. Within five years, he would have exhibitions of these new photographic tableaux at the Art Gallery of Greater Victoria, the Museum Ludwig in Cologne, West Germany, and the Renaissance Society in Chicago; his work would also be included in Documenta 7 in 1982. From then on, the litany of exhibitions is too long to list.

Finding ways to use photography to depict the world around him, Wall has devoted the majority of his adult life to making pictures of everyday situations. For this, he has classified his work into two main categories: cinematographic (which also has a kind of subcategory, "near-documentary"[8]) and documentary. He is perhaps best known for the first, which mimics aspects of film production: constructed environments and collaboration with craftsmen and performers.[9] Pictures such as *In front of a nightclub* (2006) or *Knife throw* (2008) fall under that category.[10] "Near-documentary" is his most common kind of cinematographic picture, a term he came up with while making *Adrian Walker* (1992)*: a photograph that appears to be documentary but is not.[11] This approach comes from his viewing the postwar Italian films of Luchino

Visconti, Pier Paolo Pasolini, and Vittorio De Sica, who made fictional films that feel like documentaries. Examples of Wall's near-documentary works include *Tattoos and Shadows* (2000) and *A Woman with a covered tray* (2003). *Fieldwork* (2003) is another example, as Wall photographed an anthropologist and his Stó:lō advisor while they worked. Whatever the case, the term "near-documentary," which identifies a number of salient elements of Wall's oeuvre, seems less like a category of cinematographic pictures, and more of a way to describe an unintended but inherent function of the depictive arts. The second major type, documentary, is perhaps self-evident: a picture taken of the world as it is, including landscapes or cityscapes—such as *The Old Prison* (1987) and *Coastal Motifs* (1989)—or views of places or objects—such as *Rainfilled suitcase* (2001) and *Hotels, Carrall St., Vancouver, summer 2005* (2005).

In terms of style, his tableaux fit roughly into a series of periods. The first few images, made between 1977 and 1980, are cinematographic depictions of studios or sets,[12] and they include the only two self-portraits of the artist.[13] Through the 1980s, in his second period, the work divides into two styles: either cinematographic tableaux or documentary photographs, mostly landscapes or cityscapes. The tableaux tend toward social critique, from labour unrest or racism to poverty or crime, with a pointed intent—near-didactic, so to speak—perhaps closer to the neoclassicism of Jacques-Louis David. By the third period, the work begins to take on a more panoramic scope, as in *The Storyteller* (1986),[14] and yet, at the same time, he begins to work in still life in 1990. This third period, however, becomes most realized when he starts experimenting with digital montage in *The Stumbling Block* (1991).* By 1996, at the beginning of his fourth period, he adds black-and-white photographs to his oeuvre, such as *Volunteer* (1996) and *Shapes on a tree* (1998). Here, the work becomes more contemplative, and his integration of digital montage has been perfected. This, a kind of "high" period, lasts until 2006.

From 1978 to 2006, Wall's use of lightboxes connected these various stylistic periods, all exploring the complexities of pictorial art within an avant-garde context. It is important to note that the use of the large-scale backlit transparencies as a medium is not his only innovation; the other is, of course,

12 Campany, David, "'A Theoretical Diagram in an Empty Classroom': Jeff Wall's *Picture for Women*," *Oxford Art Journal*, vol. 30, no. 1 (2007), p. 9.

13 I wonder whether Wall, now at a later point in his life, will return to self-portraiture.

14 As the City of Vancouver considers tearing down the Georgia Street Viaduct, which appears in *The Storyteller*, another image of Wall's might come to signal a passage of time.

*not included in this catalogue

15 Campany, David, *Jeff Wall: Picture for Women* (London: Afterall Books, 2011), p. 86.

16 I recall wandering through Wall's exhibition at the Museum of Modern Art in 2007, when I lived in New York, overhearing a couple ask themselves, "Is that Toronto?" To which I, unasked, replied, "No, it's Vancouver." Their faces soured in perfect haute Upper East Side fashion.

17 Wall, Jeff, "At Home and Elsewhere: A Dialogue in Brussels between Jeff Wall and Jean-François Chevrier," *Jeff Wall: Selected Essays and Interviews* (New York: Museum of Modern Art, 2006), p. 272.

18 Wall, Jeff, "Arielle Pelenc in Conversation with Jeff Wall," *Jeff Wall: Selected Essays and Interviews* (New York: Museum of Modern Art, 2006), p. 253.

digital montage, which he started experimenting with successfully in 1991, a photographic technique that we now take for granted. In these two ways, Wall has expanded how a photograph is displayed and how a photographic artwork is composed.

In front of a nightclub is a classic example, or culmination, of this kind of backlit cinematographic picture that employs digital montage. Here, an image has been taken of a nightclub on Granville Street. It has all of the elements of that period of work. A crowd gathers in front of the club's entrance. Some people are smoking, others eating, some talking, and yet others just walk on by. It portrays a rather dishevelled scene in a night on the town.

The year after Wall completed *In front of a nightclub*, he moved away from producing lightboxes. In fact, he even has begun to make photographic print versions as variants of his earlier work.[15] This shift away from his signature medium, a kind of "late" or "near-late" period, has not diminished the effect of the recent work. On the contrary, some of his recent pictures, such as *Young man wet with rain* (2011) or *Band & crowd* (2011), see him working at a level of visual sophistication that some of the earlier photographs did not possess, almost as if leaving the lightbox has freed Wall to focus on the space of the picture even more.

As a result of making most of his work at home, the city of Vancouver—and by extension the British Columbian landscape—often provided the backdrop for his scenes, thus becoming a kind of unintentional actor.[16] *Band & crowd*, for example, was shot inside an East Vancouver cultural institution, the WISE Hall & Lounge. And much like Vancouver itself, his family continues to play an important role in his work—over the past thirty years he has used as models his wife, his father, his sons, members of his family *in situ* at a local Jewish cemetery, and most recently his brother, who appears in *Monologue* (2013).

But even though depictions of Vancouver abound in his work, Wall has not been explicitly concerned with offering a definitive representation of his home and place of birth.[17] Although the British Columbian landscape does appear in his photographs, it is in the same way that the French filmmaker Robert Bresson, whose films have influenced Wall,[18] claims that an actor appears in a

film: both as himself and as the person he portrays. "A cinema film reproduces the reality of the actor," Bresson says, "at the same time as that of the man he is being."[19] Wall's hometown has acted in that way throughout his oeuvre, as both the accidental setting for a picture and as an unintended document of a place, but not as its *raison d'être*. Another term that could be used for this approach to his models is "surrogate."

But let's return to that initial mention of downtown parking lots. Throughout his work Wall is responding, in very subtle ways, to a memory of a past Vancouver. The term "near-documentary" offers a rich way to consider this aspect of his work, because near-documentary pictures, nevertheless, document actual spaces. These images are fabrications, and hence not in a strict sense "documentary," but because Wall will photograph something previously seen *in situ*, the depictions end up documenting the actual world, even if in a staged production. It is similar to the way a painting by Brueghel the Elder gives us details of what a Flemish peasant's wedding would have looked like in the 1500s, or the way a French realist novel includes details of daily life that might have otherwise disappeared with time, such as Flaubert's two brief mentions in *Madame Bovary* of the yellow pigskin gloves worn by nineteenth-century dandies.[20] It is one of the unintentional effects of depiction to document the everyday. Take, for example, the importance of those parking lots, as well as backyards and empty spaces, in Wall's pictures. We see them in *Tattoos and Shadows, A man with a rifle* (2000), and *Boy falls from tree* (2010). The backyards capture the look of a period in Vancouver, in various parts of the city. *Boy* depicts a Westside backyard, in *Tattoos* it could be in any neighbourhood, and with *A Man*, it is those urban parking lots.

While Vancouver's downtown used to be full of parking lots, it no longer is—or, rather, their replacements are now underground, perhaps a more efficient if equally unaesthetic use of space in a densifying city. The lots in the Downtown Eastside, much like the earlier ones downtown, are filling up. In the foreground of *A man with a rifle*, the figure pretending to shoot a gun stands in a gravel lot off East Hastings Street. This image, like any good one, exceeds its meaning. First, to any Vancouverite, are the social implications

19 Bresson, Robert, *Notes on the Cinematographer*, trans. Jonathan Griffin (Los Angeles: Green Integer, 1997), p. 101.

20 Flaubert, Gustave, *Madame Bovary*, trans. Lydia Davis (New York: Viking, 2010), pp. 111, 195.

21 Wall, Jeff, "Source Texts," for *Jeff Wall: Photographs 1978–2004*, Tate Modern exhibition, www.tate.org.uk/whats-on/tate-modern/exhibition/jeff-wall/resources/source-texts (accessed February 13, 2015).

22 Watters, Reginald Eyre, *British Columbia: A Centennial Anthology* (Vancouver: McClelland and Stewart, 1958), n.p.

of a man miming a rifle in the Downtown Eastside, recalling the economic inequality and mental health issues associated with that neighbourhood. Second are the formal qualities of the image, suggesting the history of pictures of men with rifles throughout Western art, from Goya to Manet. Third are the philosophical and aesthetic associations of a figure mimicking a shooter: as a study of human imitation, of *mimesis*, or how people mimic things, a reoccurring motif in Wall's oeuvre. Fourth, knowing more about his work, a connoisseur might recognize this picture as one of his cinematographic photographs. And fifth, we may see that final evidence of a disappearing Vancouver: inner-city parking lots. *A man* illustrates Wall's attention to Vancouver's vestiges.

So these traces of a vanishing city haunt his pictures. Much like family, place teaches you how to be in the world—and in this case, also how to look. Here, Wall's pictures relate to how we perceive the passing of time, how we "see" the past in the present. As such, Wall's work is reminiscent of that of French novelist Marcel Proust, his multi-volume tome *Remembrance of Things Past*, which was published between 1913 and his death in 1922, with the final volumes appearing posthumously until 1927 (and which was one of the books Wall selected for a list of "Source Texts" prepared for his 2006 Tate retrospective[21]). The book chronicles a mostly unnamed narrator as he attempts to write a novel that will restitute his memories of the past by the writing of the book that we read: lost time reclaimed through art. There is a Proustian element to Wall's project, an attempt to find the visible traces of the past in the present—not so much to reconstruct it, as Proust attempted, or to offer a definitive representation of a place, but to depict the present, and as a result to portray how, even in the present, the passage of time influences the way we see, because every image produces memories.

In 1958, the Province of British Columbia published a commemorative book, titled *British Columbia: A Centennial Anthology*, which included a variety of black-and-white photographs. In it appears an image titled *Alone on a Bridge*, of a young boy on a bicycle, riding south on the Granville Street Bridge.[22] The photograph is by Graham Warrington, published only four years after the bridge's completion. When Wall first saw the image, he told me, he wondered

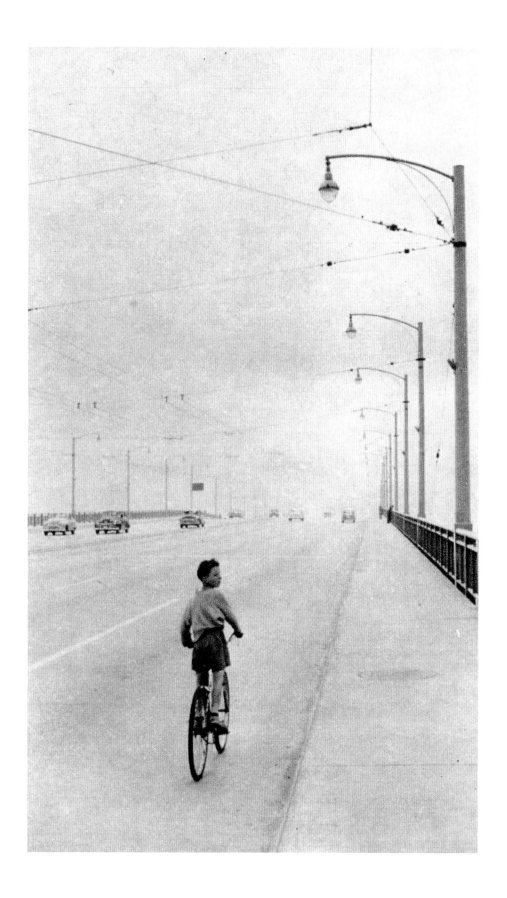

23 Wall, Jeff, "On 'Boxing,'" video, White Cube gallery website, www.whitecube.com/channel/ in_the_gallery_past/jeff_wall_ on_boxing/ (accessed February 11, 2015).

24 Stein, Gertrude, "Composition as Explanation," *Look At Me Now and Here I Am: Writings and Lectures, 1909–1945* (New York: Penguin, 1971), p. 24.

whether *he* was that boy. He looked at it closely. *He* had the same Raleigh Sports bike. *He* wore the same kind of clothes, the same kind of shorts. And *he* often bicycled back and forth over the Granville Street Bridge between the Westside and downtown, just as the boy on the bicycle was doing. It easily could have been *him*. But on closer inspection of the image, he realized it was not a photograph of him from childhood, but one of the many other boys on bicycles who also would have ridden up and down its span in the 1950s.

Wall's misrecognition is a telling one, particularly for an artist who has attempted to recreate things seen, and even memories, through making depictions of them, and who has mentioned that he is responding to a past time. *Boxing* (2011), for example, comes from a memory the artist has of sparring with his brother in their family's living room.[23] But in this photograph, the décor and setting are not from the 1950s. Rather, Wall presents the situation in a current setting, with young twenty-first century brothers. As a result, the image is both the representation of a memory and a picture of brothers boxing in a contemporary living room. In a sense, past and present merge.

In "Composition as Explanation," a lecture given at Cambridge and Oxford in 1926, modernist writer and art collector Gertrude Stein meditated on the relationship between artworks and time. Particularly, she related our experience of the present to seeing: "The only thing that is different from one time to another is what is seen and what is seen depends upon how everybody is doing everything. This makes the thing we are looking at very different and this makes what those who describe it make of it, it makes a composition, it confuses, it shows, it is, it looks, it likes it as it is, and this makes what is seen as it is seen. Nothing changes from generation to generation except the thing seen and that makes a composition."[24]

In this somewhat playful, at times confounding language, Stein suggests that for artists to successfully make work about their time they need only to see it. How one would rightly see one's time, however, is a question she leaves unanswered.

Wall explores seeing in contemporary life, and thus composes it. But the "time" that Wall attempts to picture is complex. Recreating scenes from life,

whether they are memories of boxing as a child, or of a man on the street with a gun, or of a bustling nightscape, are not only attempts to use the camera as a tool to arrest time as it passes, but also to recreate it—and by doing so, attempt to see it through making a depiction of it, to compose it. Consider that last major backlit transparency, *In front of a nightclub*. For anyone who lived in the city of Vancouver in the first decade of the twenty-first century, the picture might be oddly uncanny. It is an image of a now-defunct nightclub on Granville Street called the Stone Temple. The groups of people loitering outside recall the clientele who used to patronize it. Even the rose seller (who, for me, is the main subject of the picture) resembles the kind of men who wander Granville Street on weekends, hoping to make a few dollars selling flowers to club-goers attempting one-night stands. All of these things happen in any city. So you have an image that depicts a certain kind of place, a certain kind of situation, with certain kinds of people, who are recognizable to any early twenty-first century city dweller. Anybody can see this as they walk across a city on a weekend night. It might not be the hippest or most fashionable crowd, but it is a common scene. Its uncanny nature is even greater for residents of Vancouver who might recognize that particular strip of Granville Street, even that specific establishment.

One question arises: how did Wall take the picture? There are three possibilities. He either took it documentary-style, which is near impossible, or he paid for a permit to block off the street for a night of shooting à la "near-documentary," also unlikely due to the amount of time it takes Wall to make a picture, or he could have recreated the entire façade of a tawdry and, at its time of composition, contemporary Vancouver nightclub. In fact, it is the third. Here, he has reconstructed a very mundane strip of Vancouver's downtown club district. And yet strangely, although entirely fake, it has the semblance of a document, of a specific time and place. *In front of a nightclub*, then, is one of those pictures that "sees" its time, but only through recreating it with the production quality and techniques of cinema. That nightclub is now closed. And to look at the picture, for those of us who remember the place at all, is to see something odd. We might ask ourselves: Do we remember that security

25 Baudelaire, Charles, *The Painter of Modern Life and Other Essays*, trans. and ed. Jonathan Mayne (New York: Phaidon, 1970), p. 14.

26 Wall, Jeff, *Depiction, Object, Event* (s'Hertogenbosh: Hermes Lecture Series, 2006), pp. 12–13.

27 But how do we "see" *him*? I want to finish this essay, here in a rather literal endnote, with a personal anecdote. In 2008 or 2009, I was asked by a friend, who works at a support home in the Lower Mainland for adults with disabilities, to sit on a jury for an art prize. I was to help select a series of paintings that would be auctioned to fundraise for the organization. Artists, who responded to an open call, were to submit one painting and a statement. The majority were hobbyist watercolourists, and so, it turned out, were the jury members. Among the tepid landscapes, I noticed a rather odd but charming oval acrylic portrait. Depicting a man with mid-length hair, in a purple bowtie and green shirt, against a grey backdrop, the colours were almost Fauvist. I felt as compelled by it as Edgar Allan Poe was by his oval portrait. The figure looked strangely familiar, so when I consulted the artist's statement, I was delighted to discover that it was a portrait of Jeff Wall. In the statement, the artist described having been a student of Jeff's at Simon Fraser University many years ago, and how much he had been inspired by him. A year later, when I relayed the anecdote, Jeff asked me who the artist was. As I could not recall, I emailed my friend, still working for that organization, to ask him to track down the information. When I finally gave Jeff the answer, he informed me that he knew that artist; that he, indeed, had been his teacher; and that they still stayed in touch. He even has a few of his paintings.

camera? Did I ever see that rose seller? Or party with that girl in the silver high heels? But although it appears to be a real document of the club, it is the document of a replica. To use the categories established by the artist himself: even though something about it appears to be documentary, it is cinematographic. And yet, much like paintings of everyday life from the past, *In front of a nightclub*, nonetheless, documents the styles, attitudes, and forms of its time. Such is the nature of depiction.

As this essay began with a quote from Baudelaire, it seems fitting to end with another. In his seminal 1863 essay "The Painter of Modern Life," the *poète maudit* said, "Every age has its own gait, glance, and gesture."[25] Jeff Wall's work has attempted to depict just that. For him, photography becomes a way, through the legacy of the avant-garde, to further the project of the depictive arts,[26] which, by an accident of their nature, document the spirit and details of the time in which a particular artwork is composed. In photographs that attempt to recreate something that is past, Wall's pictures compose their present. It's one of the paradoxes of depiction: the way in which you can represent images of the past in pictures of the present. And the way Wall sees, the way he glances, may be the product of a disappearing time, of a city and its vicissitudes, of ways of life in one place that have drifted into the slumber of history. That kind of seeing, however, is how we depict the contemporary, how our time is composed, much as younger artists will look upon a future Vancouver with the eyes of this present.[27]

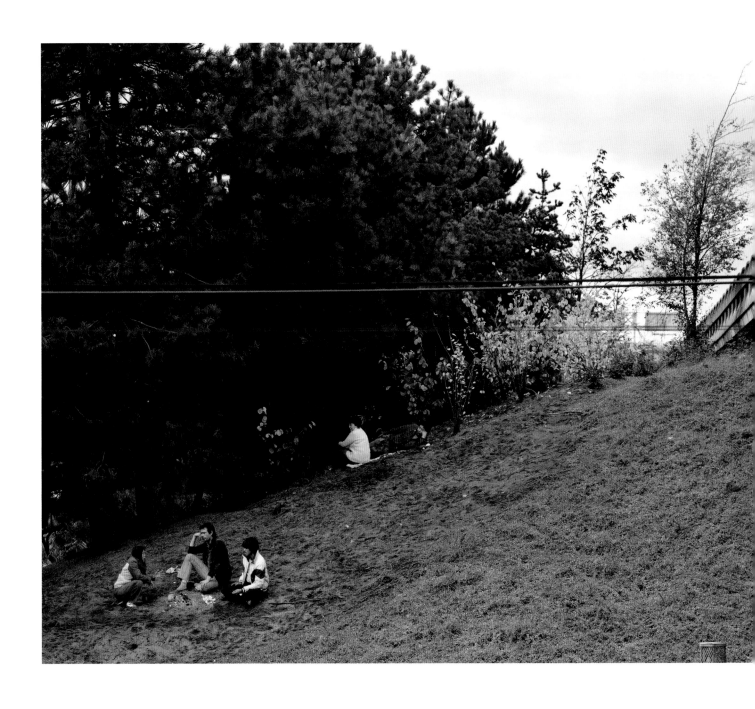

The Storyteller 1986
transparency in lightbox
229.0 × 437.0 cm

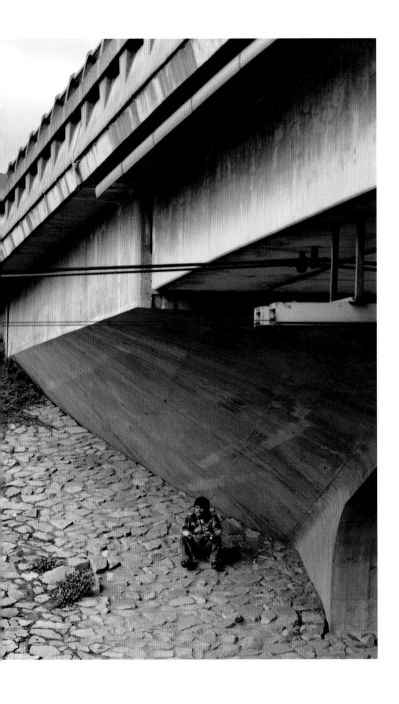

The Old Prison 1987
transparency in lightbox
70.0 × 228.6 cm

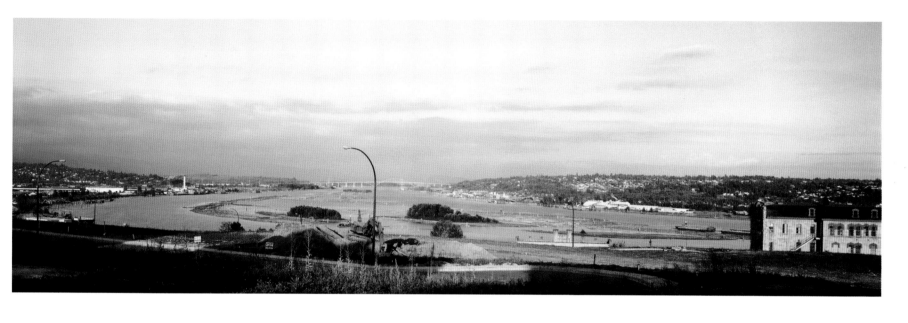

Coastal Motifs 1989
transparency in lightbox
119.0 × 147.0 cm

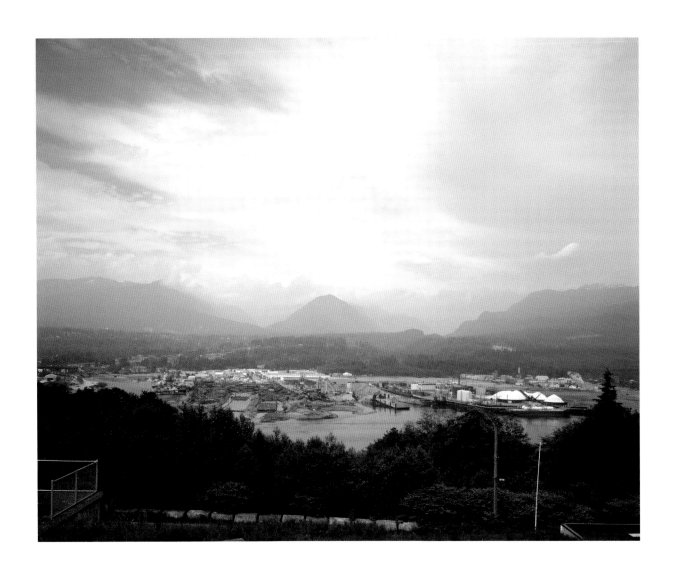

Volunteer 1996
silver gelatin print
221.5 × 313.0 cm

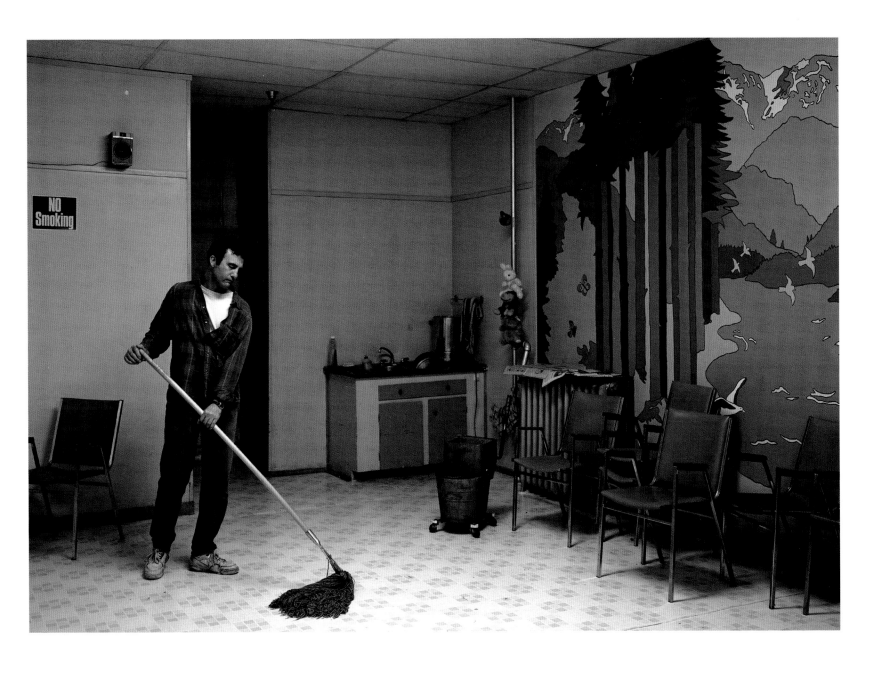

Shapes on a tree 1998/2014 (new edition)
silver gelatin print
96.3 × 74.3 cm

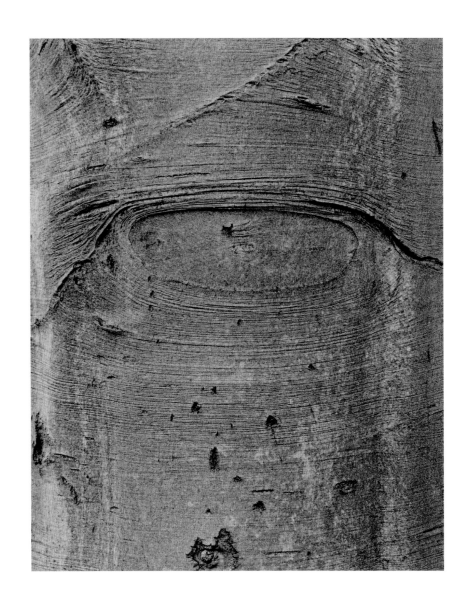

Clipped Branches, E. Cordova St., Vancouver 1999
transparency in lightbox
71.8 × 89.0 cm

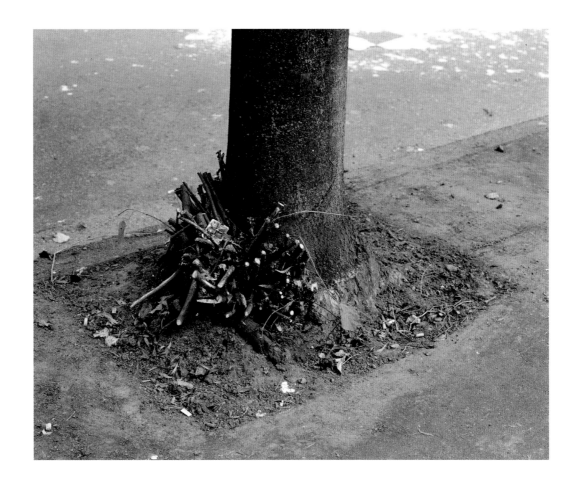

A man with a rifle 2000
transparency in lightbox
226.0 × 289.0 cm

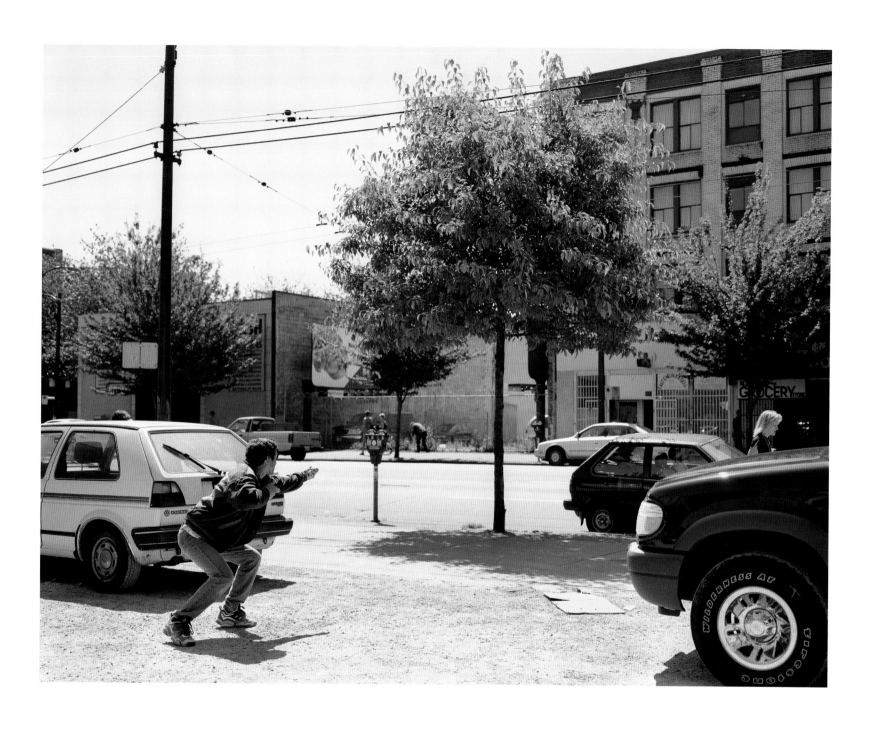

Tattoos and Shadows 2000
transparency in lightbox
195.5 × 255.0 cm

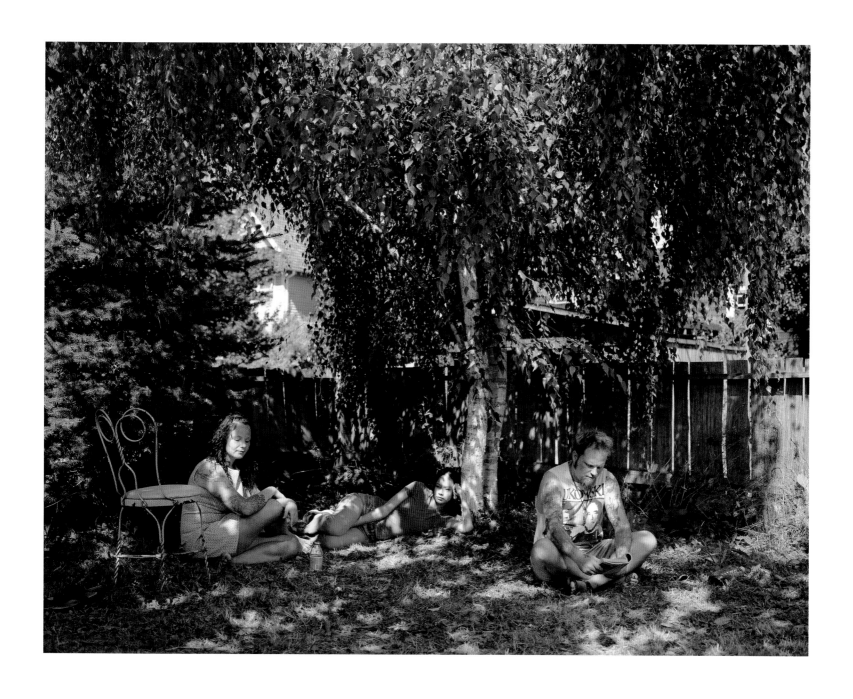

Night 2001
silver gelatin print
238.8 × 301.6 cm

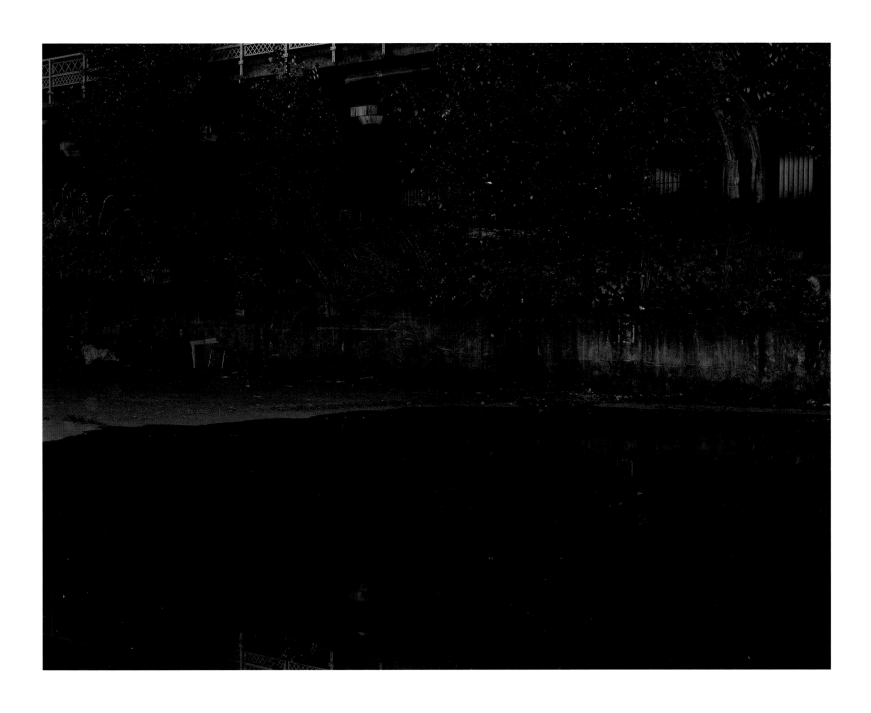

Rainfilled suitcase 2001
transparency in lightbox
64.3 × 79.8 cm

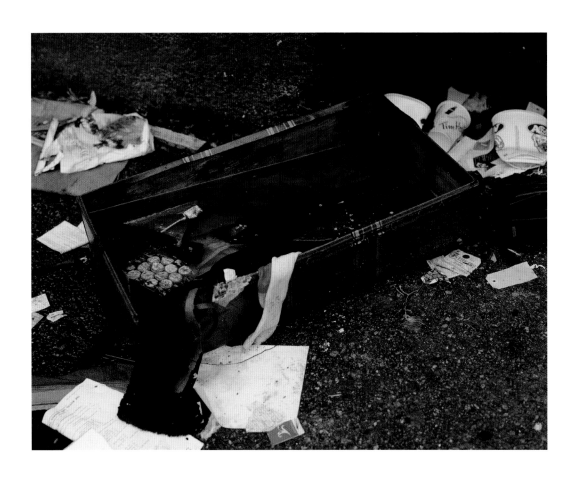

A woman with a covered tray 2003
transparency in lightbox
164.0 × 208.6 cm

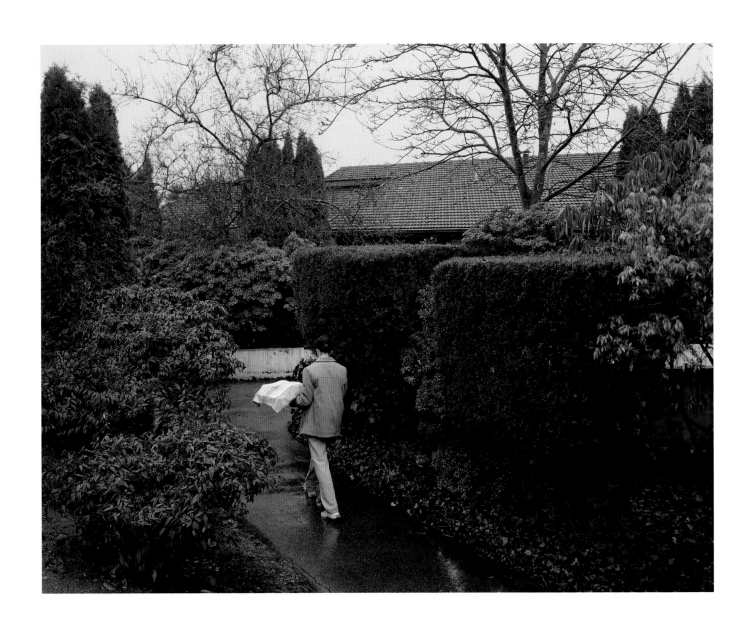

Fieldwork. Excavation of the floor of a dwelling in a former Stó:lō
Nation village, Greenwood Island, Hope, British Columbia, August 2003.
Anthony Graesch, Department of Anthropology, University of California
at Los Angeles, working with Riley Lewis of the Stó:lō band 2003

transparency in lightbox
219.5 × 283.5 cm

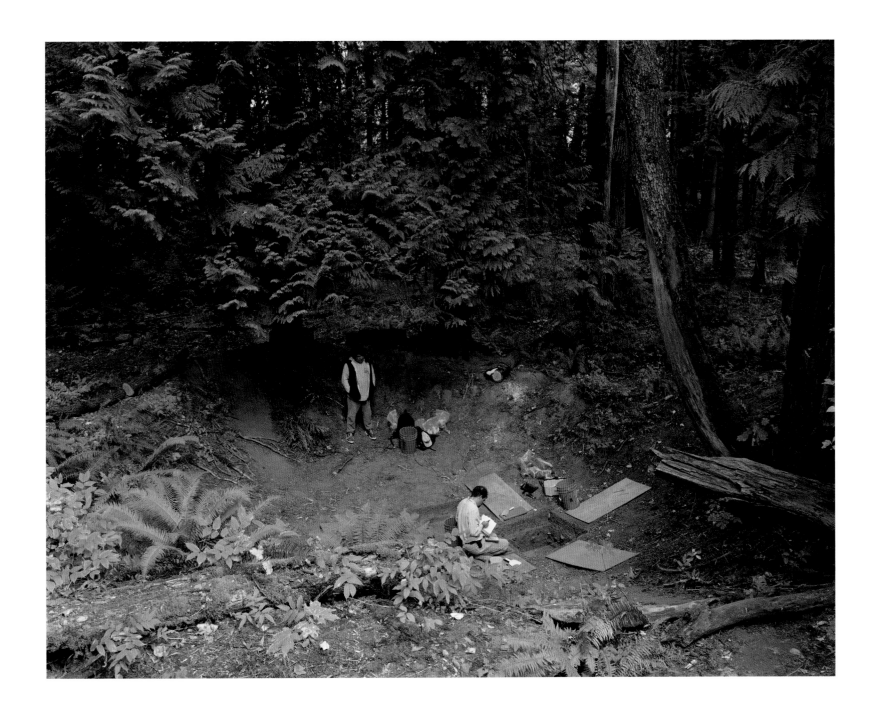

Hotels, Carrall St., Vancouver, summer 2005 2005
transparency in lightbox
249.0 × 312.0 cm

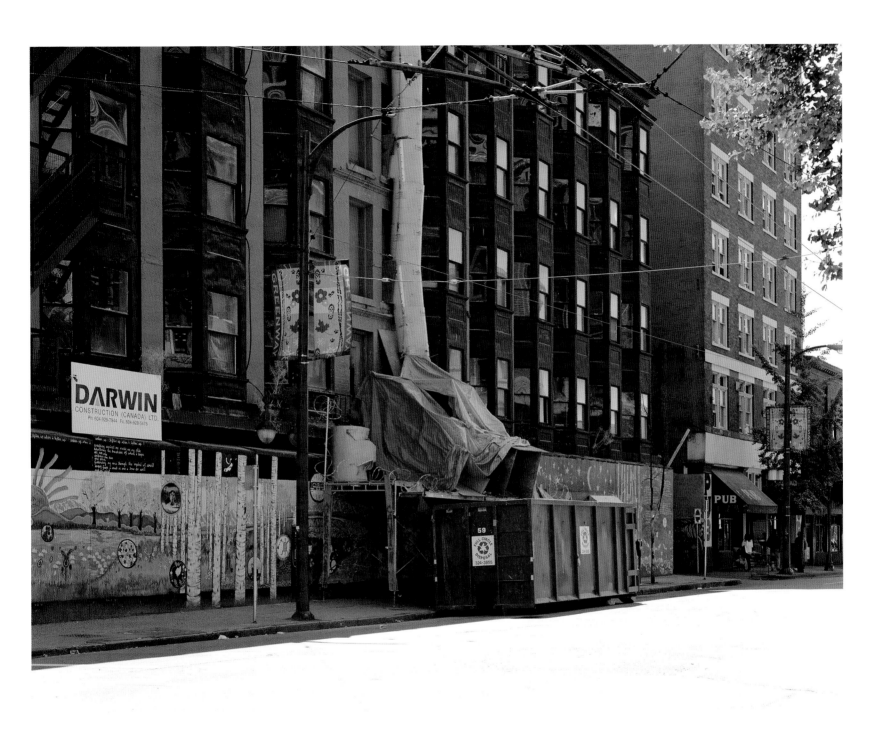

In front of a nightclub 2006
transparency in lightbox
226.0 × 360.8 cm

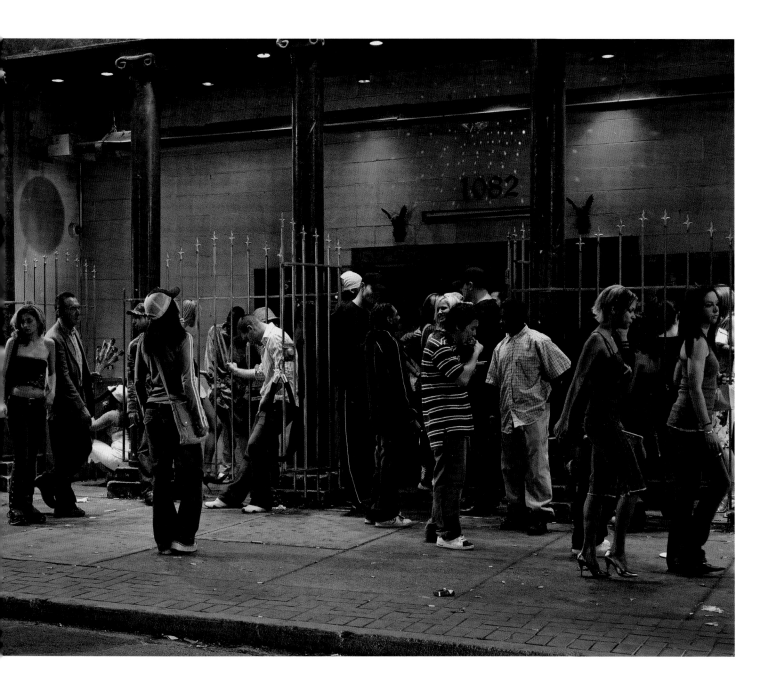

Fortified door 2007
silver gelatin print
153.0 × 126.0 cm

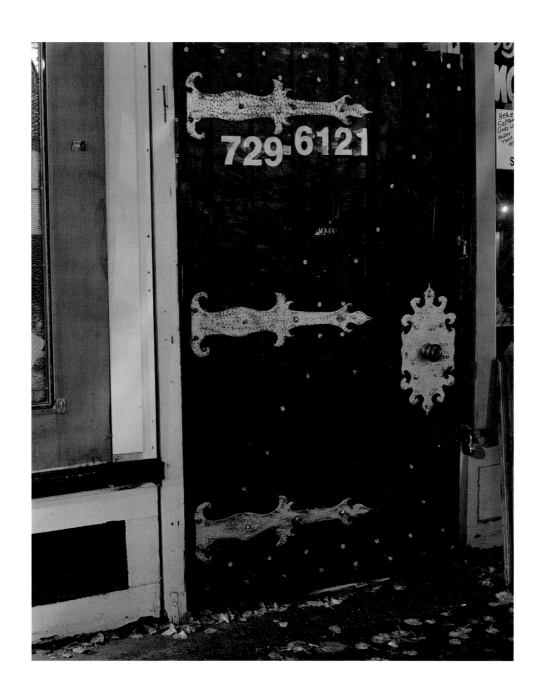

Knife throw 2008
colour photograph
184.0 × 256.0 cm

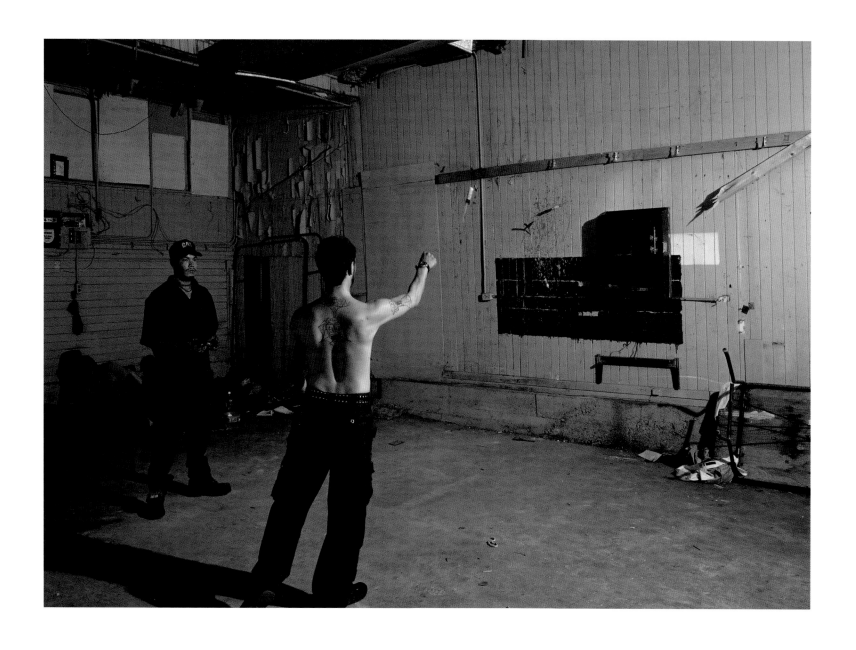

Boy falls from tree 2010
colour photograph
226.0 × 305.3 cm

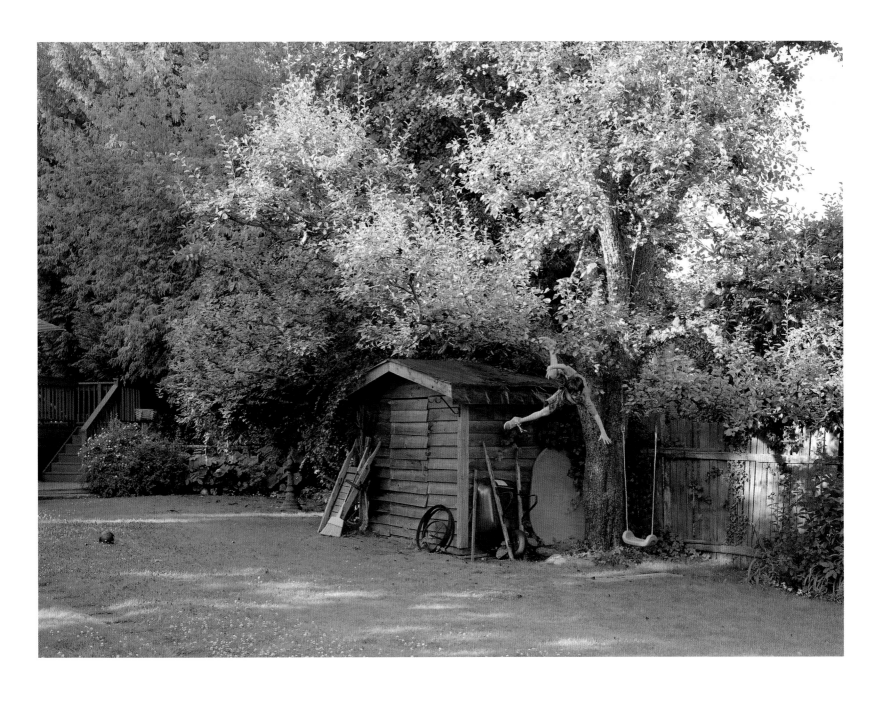

Young man wet with rain 2011
silver gelatin print
275.2 × 149.6 cm

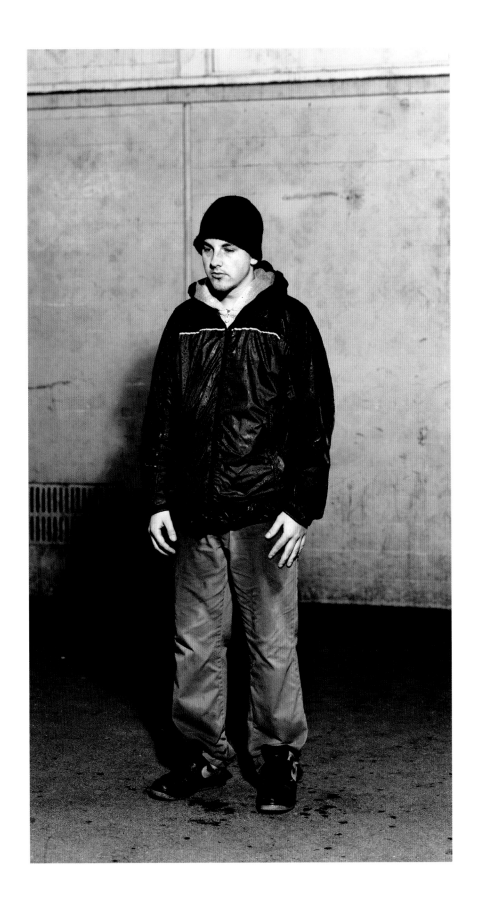

Boxing 2011
colour photograph
215.0 × 295.0 cm

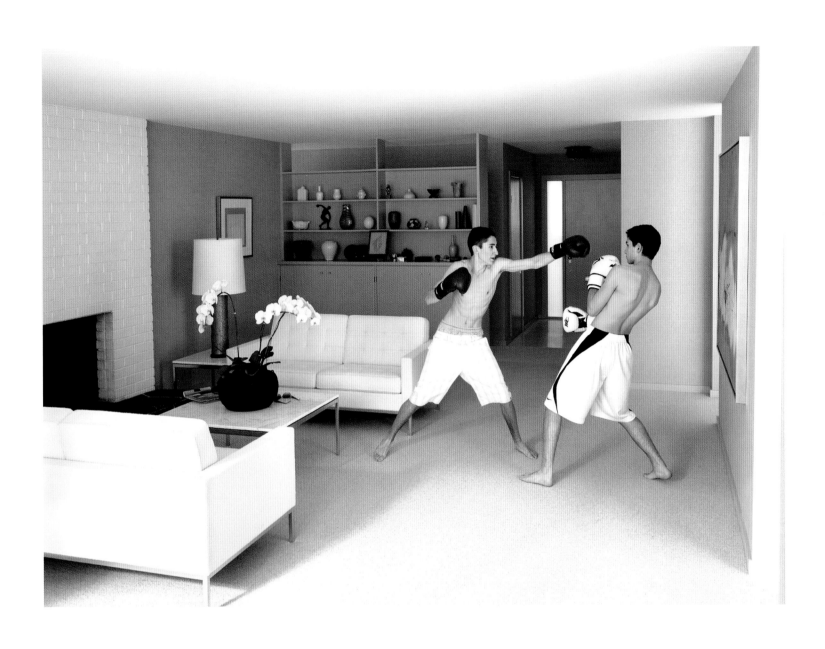

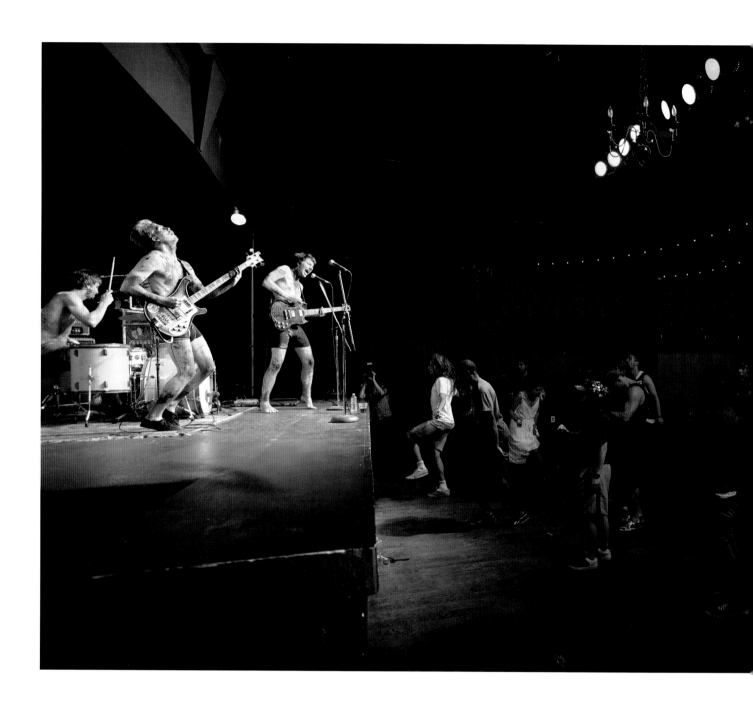

Band & crowd 2011
colour photograph
229.0 × 420.0 cm

Monologue 2013
colour photograph
240.0 × 282.3 cm

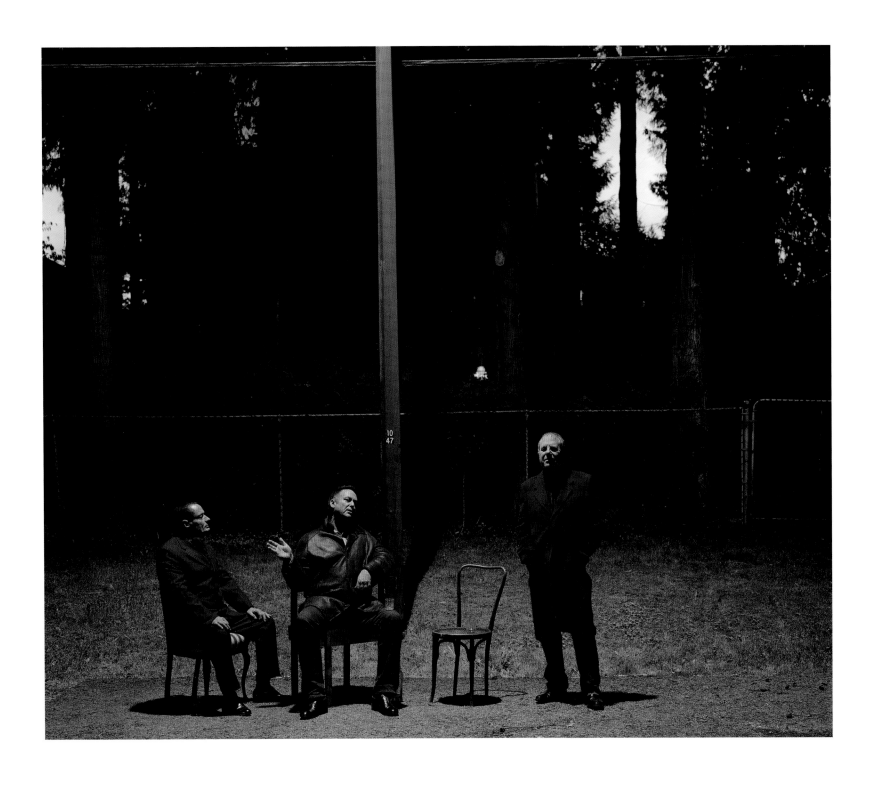

Contributors

SUZANNE E. GREENING, Executive Director of the Audain Art Museum, has embraced her passion for the arts through a lifelong career in the arts community in Canada and the United States. She has had extensive experience starting up new museum facilities, previously acting as the Director of the Canadian Clay & Glass Gallery in Waterloo, Ontario, the Museum of Glass and Chihuly Bridge of Glass in Tacoma, Washington, and The Reach Gallery Museum in Abbotsford, British Columbia. Suzanne has also been actively involved on cultural and community-based boards such as the Chamber of Commerce, the Glass Art Society, KCTS 9, and Rotary International.

AARON PECK is the author of *The Bewilderments of Bernard Willis* and *Letters to the Pacific*. He also is a frequent contributor to *Artforum*. In 2012, he was invited to be a participant in Documenta 13 as a writer-in-residence. He lives in Vancouver, British Columbia, where he is a lecturer at Emily Carr University of Art + Design.

JEFF WALL, OC, was born in 1946 in Vancouver, British Columbia, where he lives and works. He has exhibited his photographs internationally for the past thirty-five years. His pictures, in both black-and-white and colour, are usually large in scale and done in collaboration with performers. He calls them "cinematographic." Wall is considered to be one of the artists who has led the way in emphasizing the affinities between photography, painting, and cinema. His work is included in many major public and private collections, including the Centre Georges Pompidou, Paris, the Tate Modern, London, and the Museum of Modern Art, New York. He taught art in universities in Canada for twenty-five years, and his critical writing has been collected and published in several languages. He has been awarded several prizes, including the Hasselblad Award for photography in 2002, the Roswitha Haftmann Prize in 2003, and the Audain Prize in 2008.

JEFF WALL: NORTH & WEST
JANUARY – MAY 2016

Cataloguing data available from Library and Archives Canada
ISBN 978-1-927958-48-3 (hbk.)

Editing by Pam Robertson
Proofreading by Renate Preuss
Design by Jessica Sullivan

Front cover image: *Fieldwork* (detail), 2003. Back cover image: *Monologue*, 2013.
Printed and bound in China by 1010 Printing International, Ltd.
Distributed in the U.S. by Publishers Group West

Figure 1 Publishing Inc.
Vancouver BC Canada
www.figure1pub.com

Audain Art Museum
Whistler BC Canada
www.audainartmuseum.com

IMAGE CREDITS
All works of art represented in this catalogue are from
the collection of the artist, with the exception of *Hotels, Carrall St.,
Vancouver, summer 2005*, which is owned by the Audain Art Museum.
All images of works by Jeff Wall represented
in this catalogue are provided courtesy of the artist.

Photo of *Alone on a Bridge* by Graham Warrington (p. 8) appears
courtesy of Justine Warrington and the family of Graham Warrington.